# A is for

# AFRICA

## Coloring Book

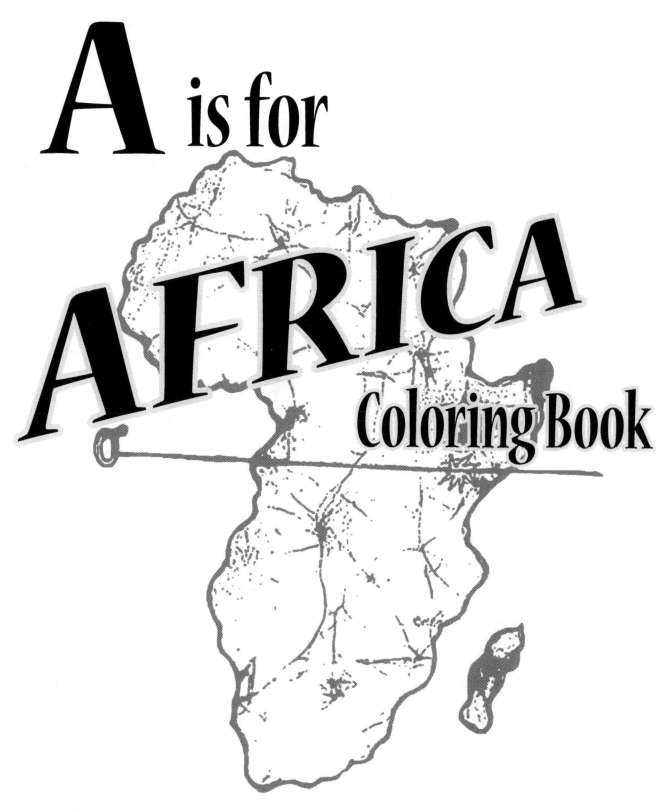

# Written by Michael I. Samulak
# Illustrated by Sswaga Sendiba

Order this book online at www.trafford.com
or email orders@trafford.com

Most Trafford titles are also available at major online book retailers.

Print information available on the last page.

ISBN: 978-1-4269-4097-2 (sc)
ISBN: 978-1-4269-4098-9 (e)

Library of Congress Control Number: 2010913087

Special thanks to Michael Brenneman for designing the cover and graphics editing.

Trafford rev. 04/26/2024

North America & international
toll-free: 844-688-6899 (USA & Canada)
fax: 812 355 4082

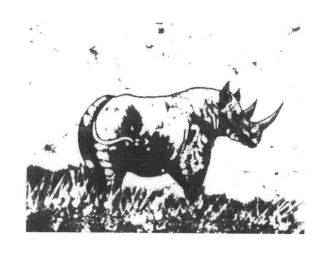

*For my son Jonathan, love Daddy.*

# A is for Africa.

Africa is an awesome land, as we soon shall see. It is home to many amazing animals, people, and trees.

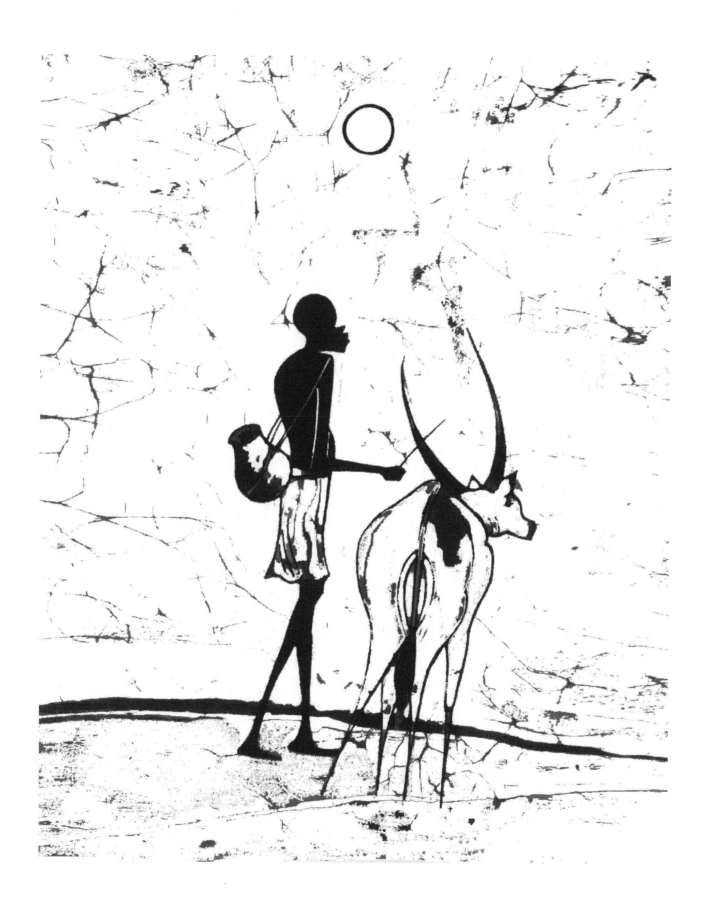

# B is for baboon.

The baboon has an energy that is playful, but tough. Don't cross his path or things could get rough.

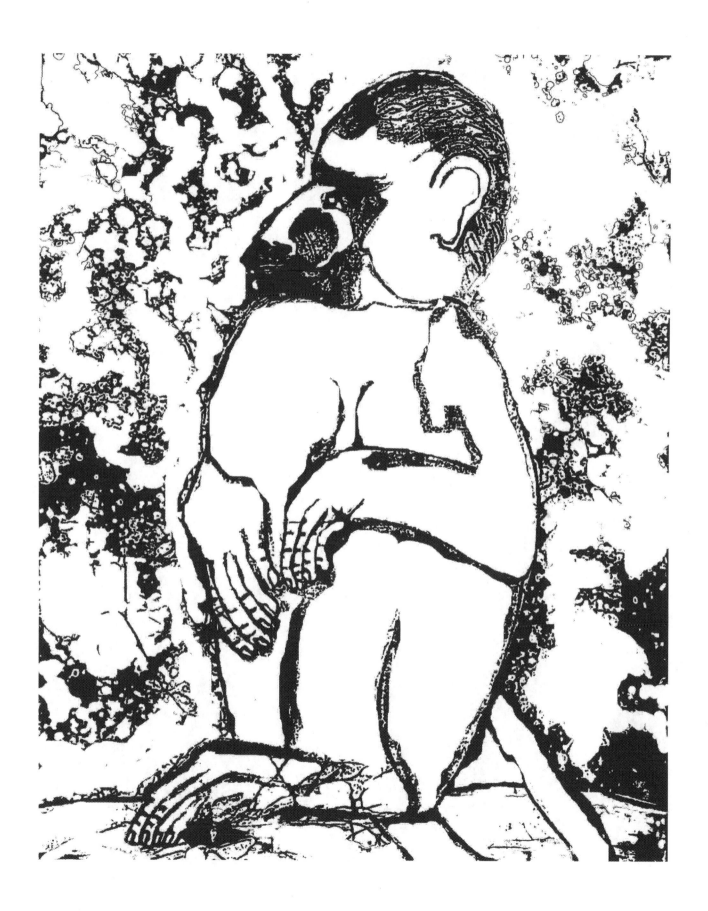

# C is for cheetah.
*"Swift as a cheetah"*, so it is
said both near and far.
Running at top speed,
these cats can keep up
with your car!

# D is for drum.

## The drum is an instrument of choice whose rhythm and beat make the people rejoice!

# E is for elephant.

# The elephant moves steady and slow. Together in herds they often go.

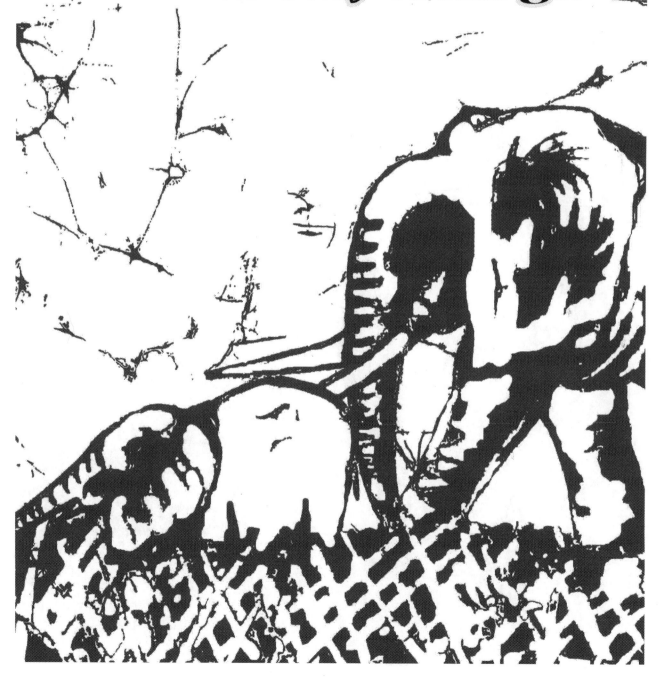

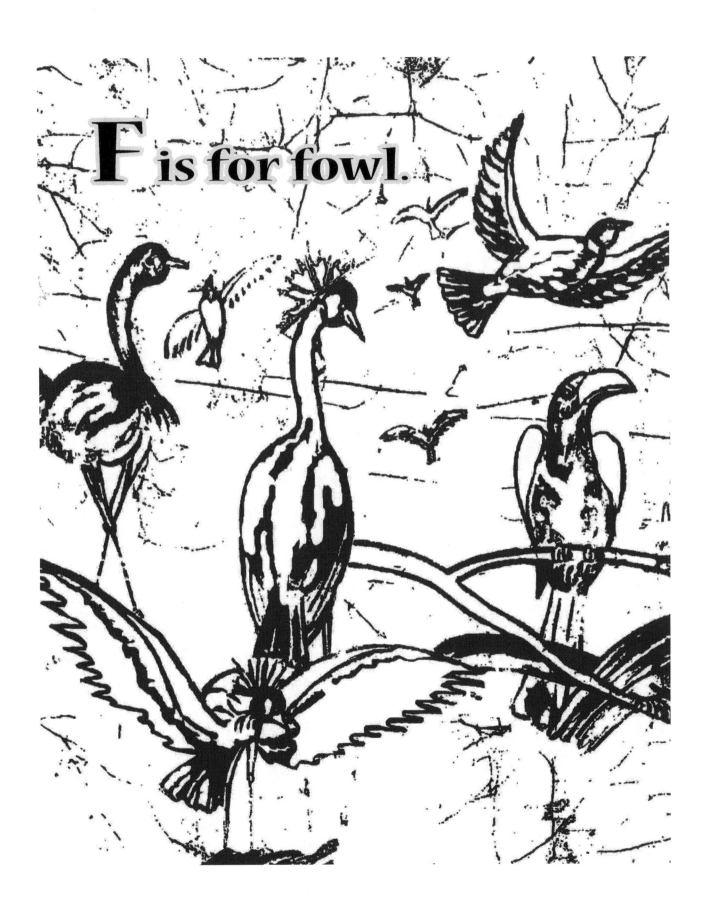

**F** is for fowl.

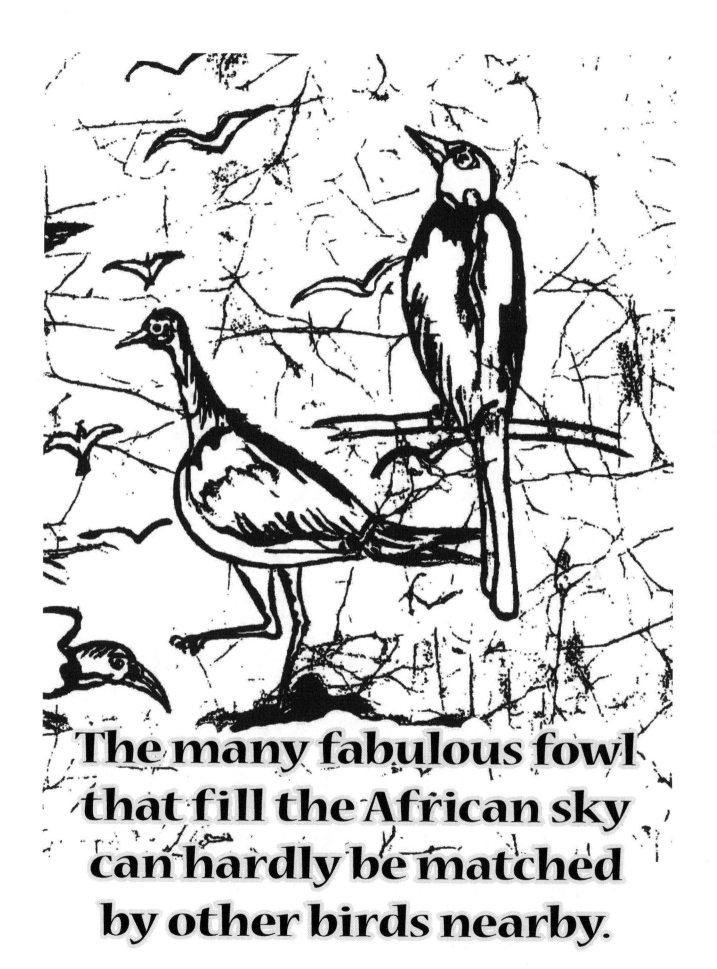

**The many fabulous fowl that fill the African sky can hardly be matched by other birds nearby.**

# G is for giraffe.

The giraffe is the gentle giant of the land. She stands head and shoulders above every animal or man.

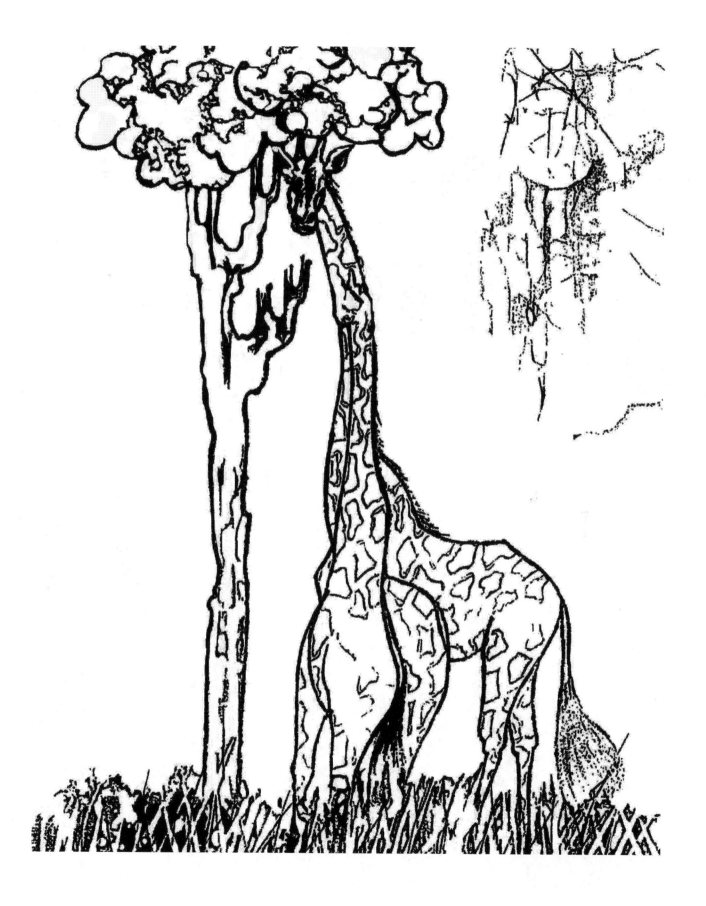

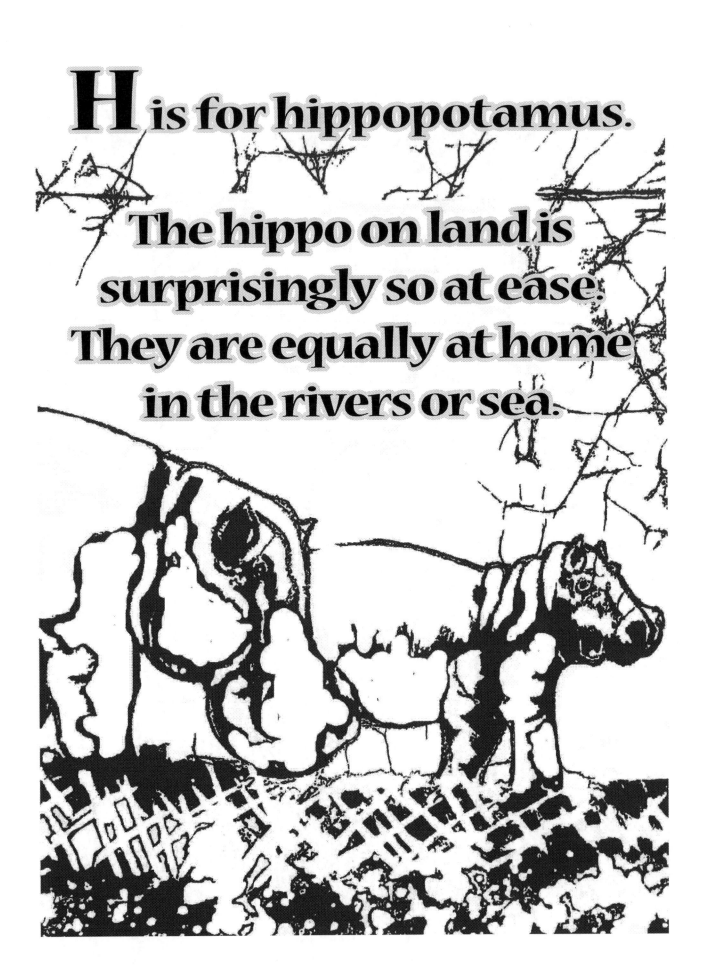

# H is for hippopotamus.

The hippo on land is
surprisingly so at ease.
They are equally at home
in the rivers or sea.

# I is for ibis.

The ibis, a bird with a long slender beak, searches and probes for a nice tasty treat!

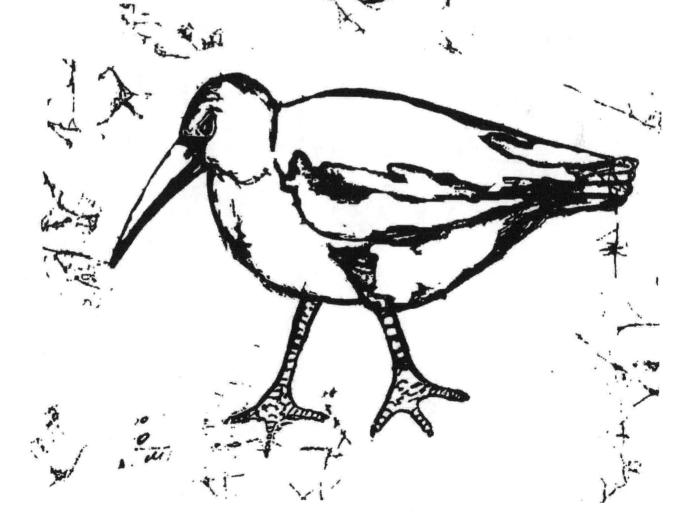

# J is for jars.

The jars of earth and wood made here are impressive indeed, and yet so useful for everyday needs.

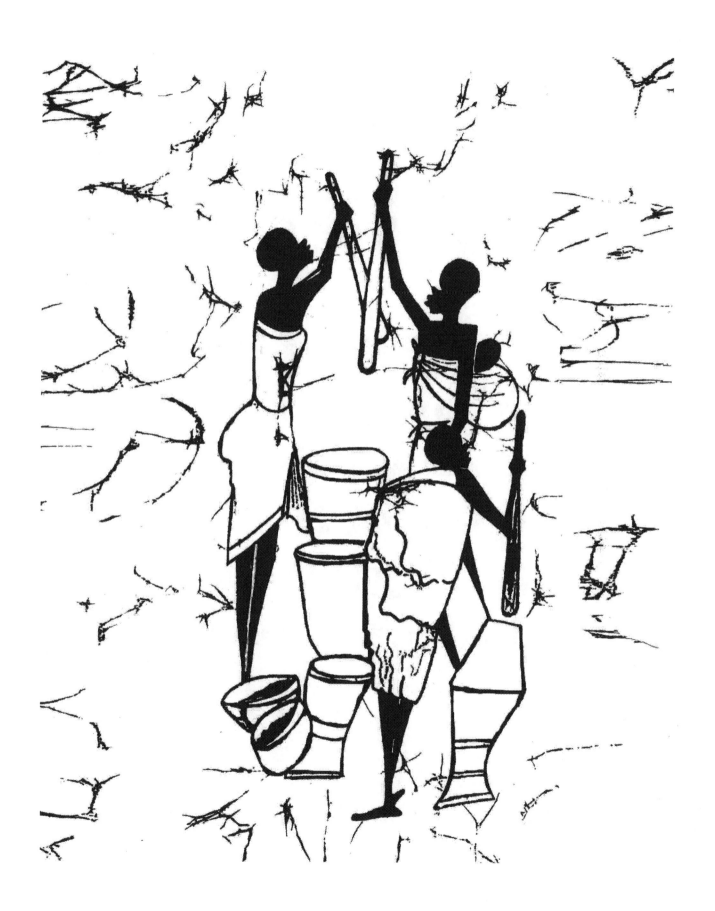

17

# K is for kob.

The kob is a kind of African antelope. It spends its time grazing in fields, or bounding about on a hill or a slope.

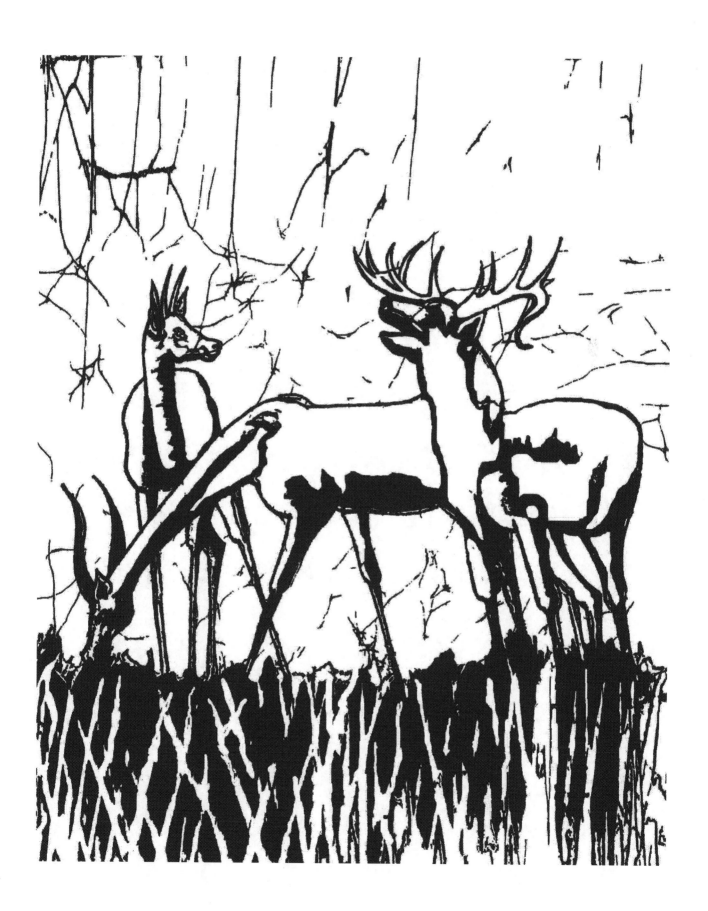

# L is for lion.

**The lion surveys the land with heart-filled pride. This king of beasts wields a mighty roar and has a piercing eye.**

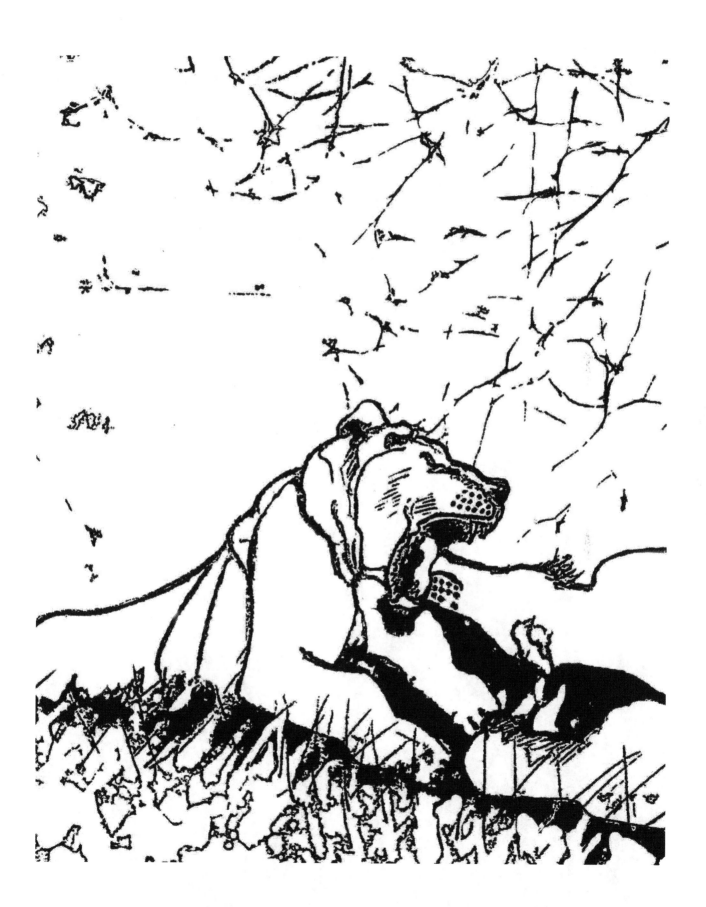

# M is for mountain gorilla.

## The mountain gorilla is quite simply magnificent - loving, strong, and highly intelligent.

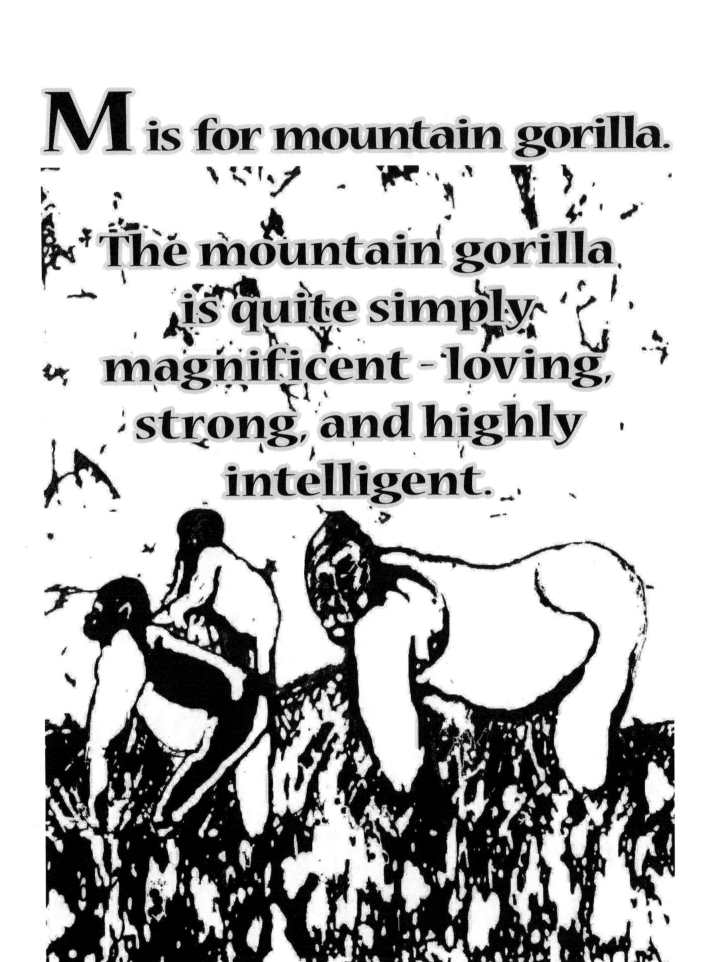

# N is for Nile crocodile.

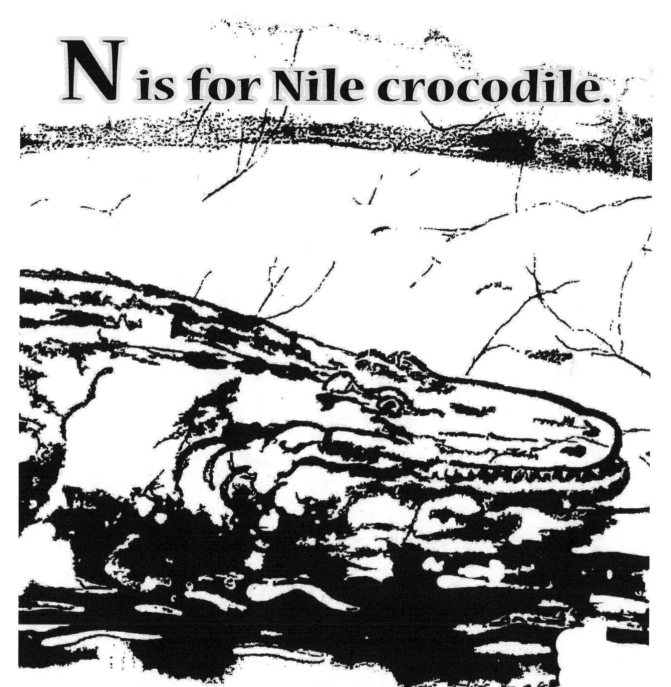

The Nile crocodile is mysterious, silent, and sleek. In the river he lies, without making a peep.

# O is for ostrich.

The ostrich is known for her long neck and strong legs. She also is famous for laying large eggs.

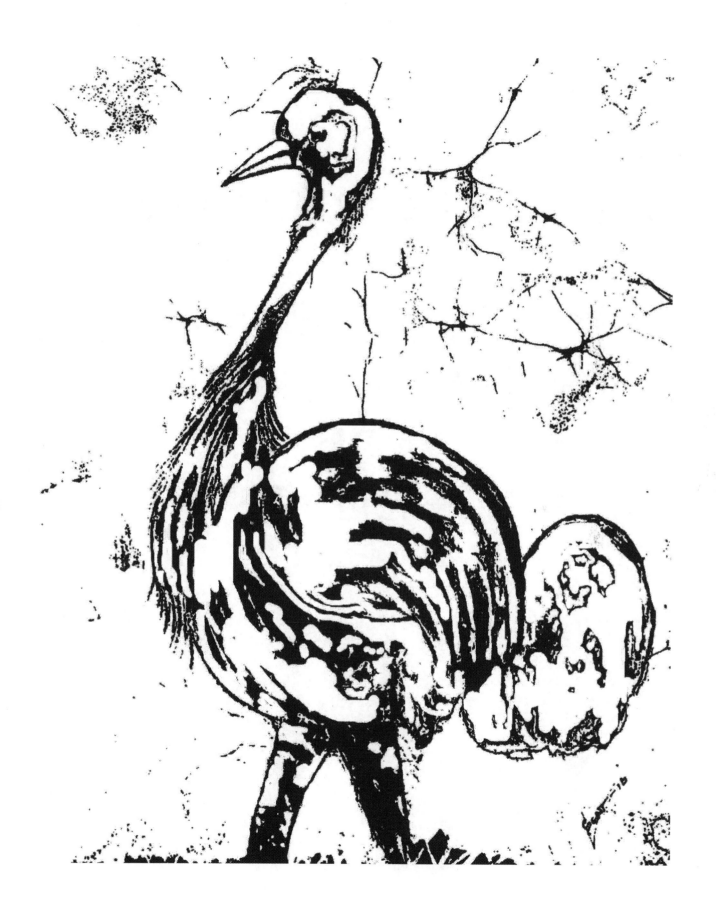

# P is for pygmy chimpanzee.

The pygmy chimpanzee's face reveals a soul that is caring, imaginative, and ever so thoughtful.

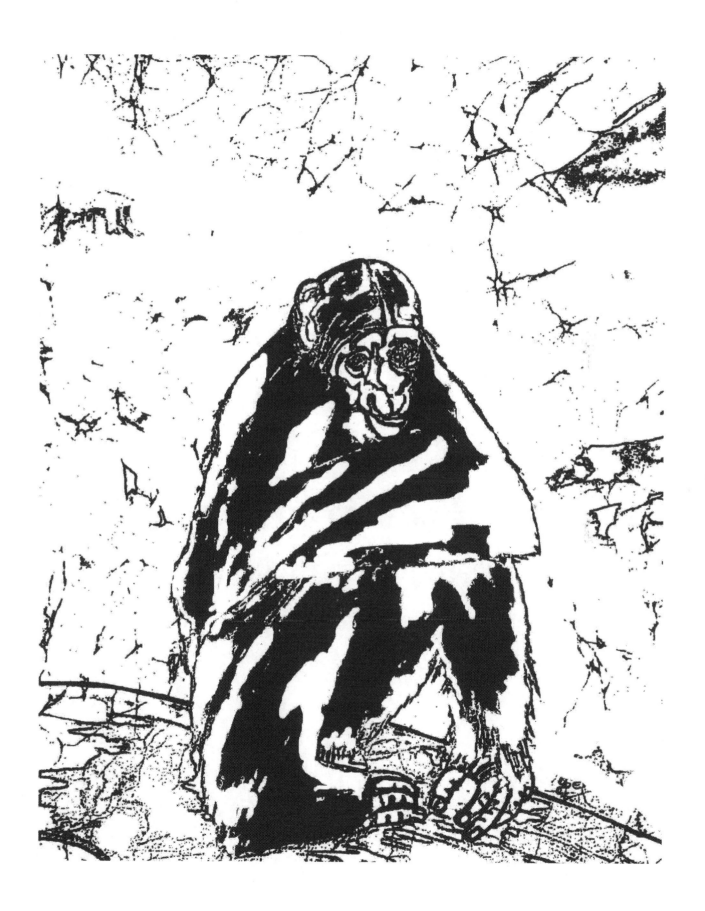

# Q is for queen.

The queen of the village is the oldest woman who is gentle as a dove. She is adorned with all wisdom and always acts in love.

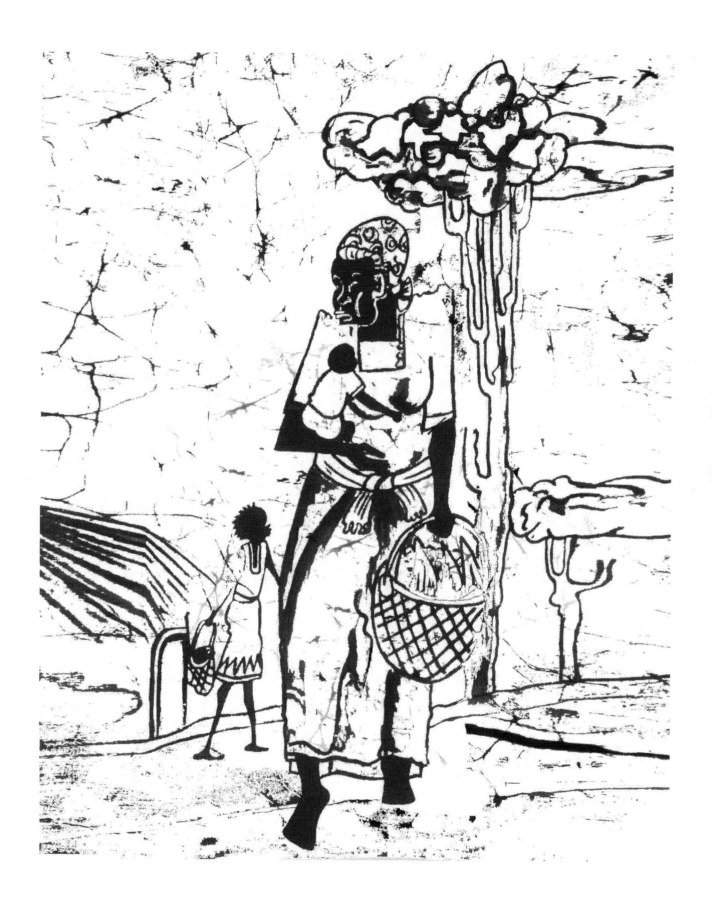

# R is for rhinoceros.

## The rhino's horn is beautiful, long, and white. It forever displays courage and strength to foe and friend alike.

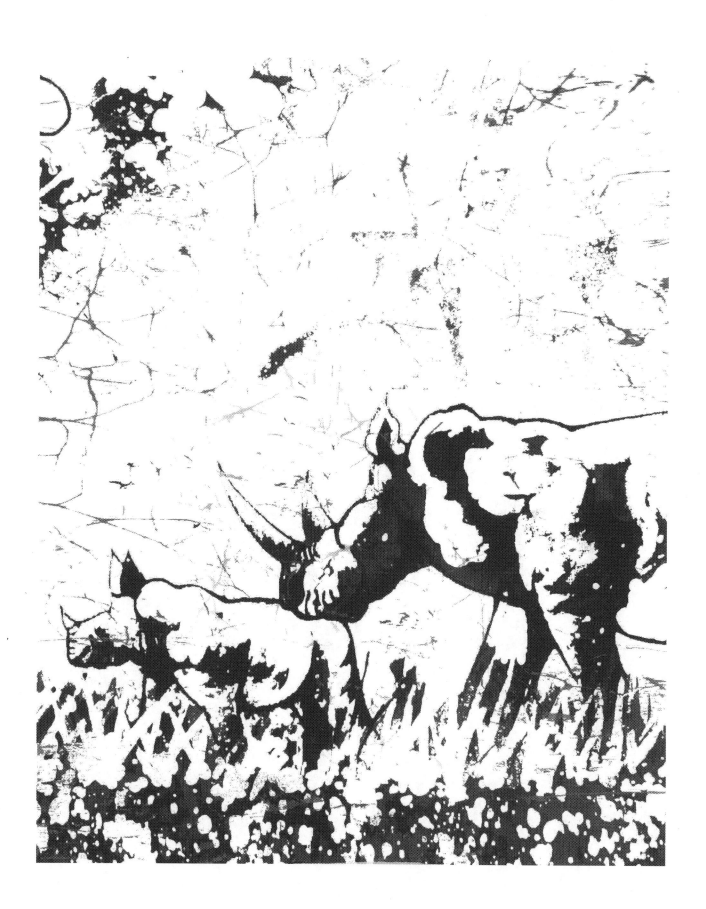

**S** is for spotted hyena.

The spotted hyena live together in groups called clans. They hunt in packs, or simply wait, to clean up after others in the land.

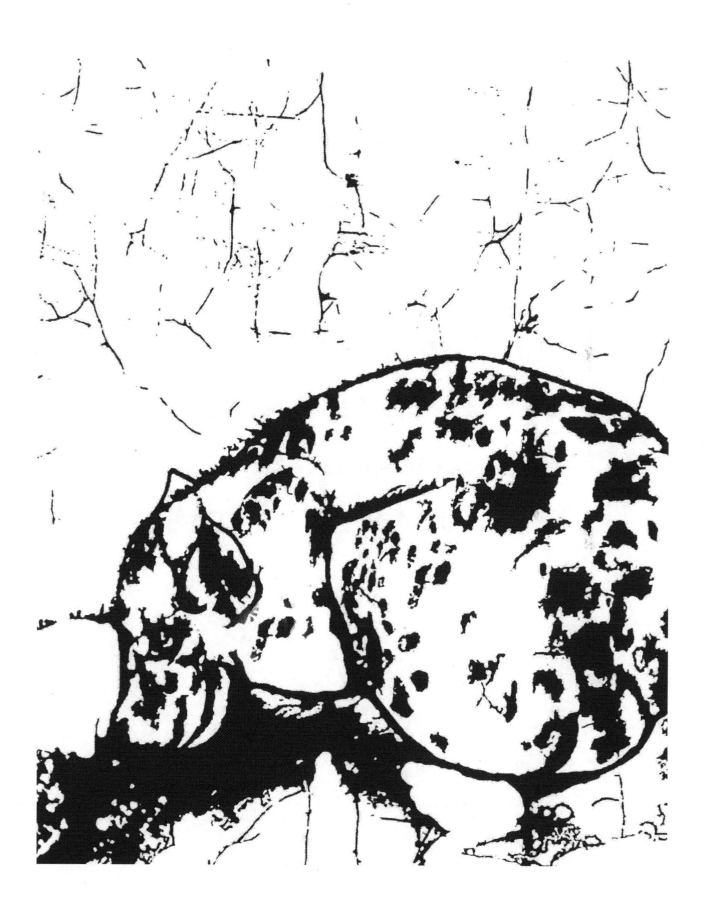

# T is for tilapia.

The tilapia fish a prize catch does make for all those hard at work on the rivers and lakes.

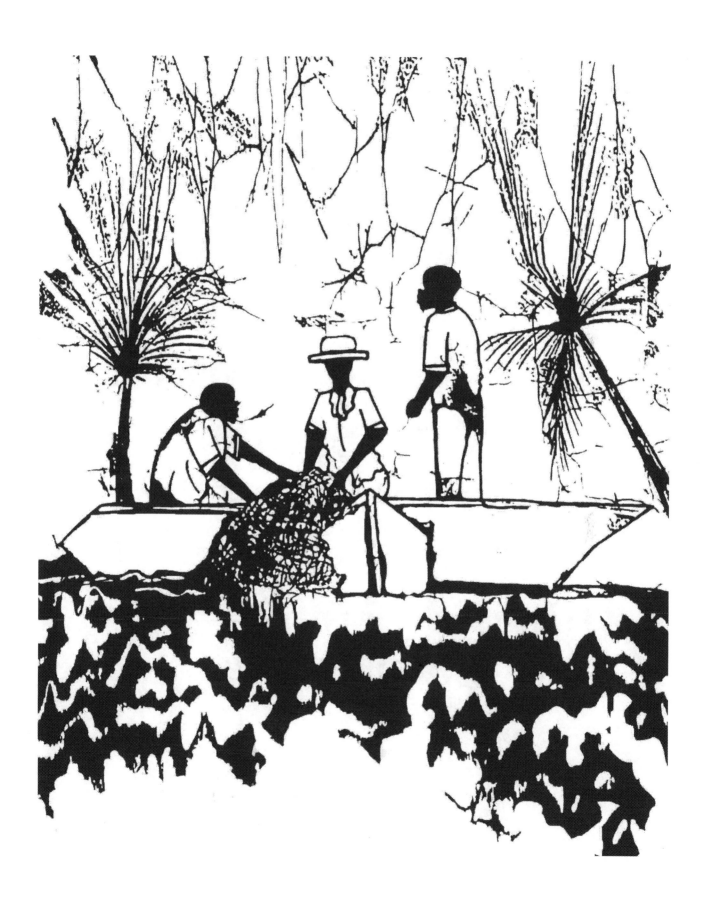

# U is for Uganda's crowned crane.

This crane is a national symbol of Uganda, *"The Pearl"*. Their feathers adorn the crowns of kings and the heads of young girls.

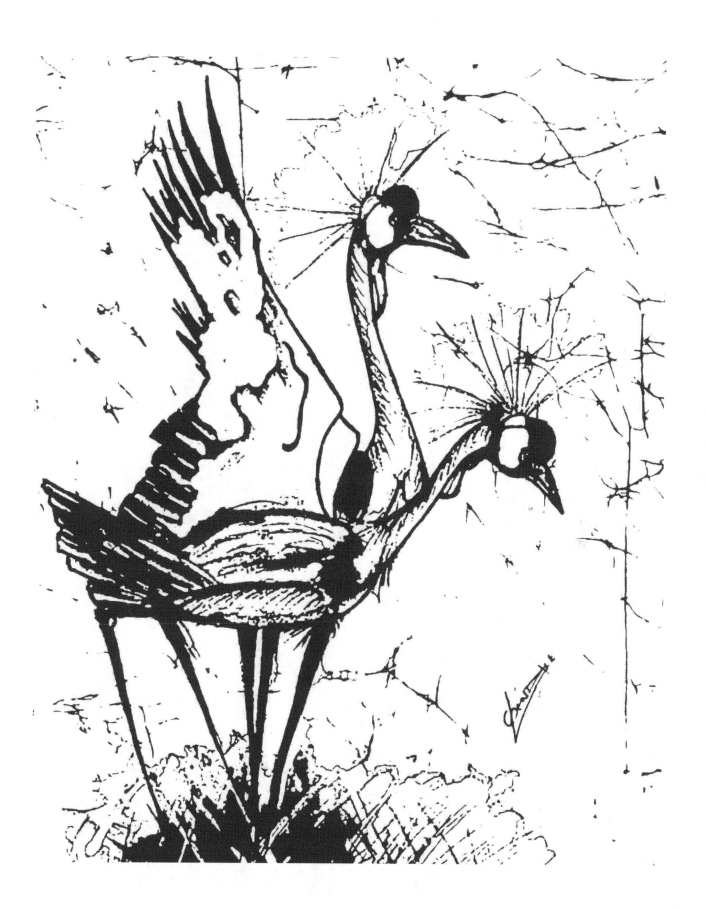

# V is for village.

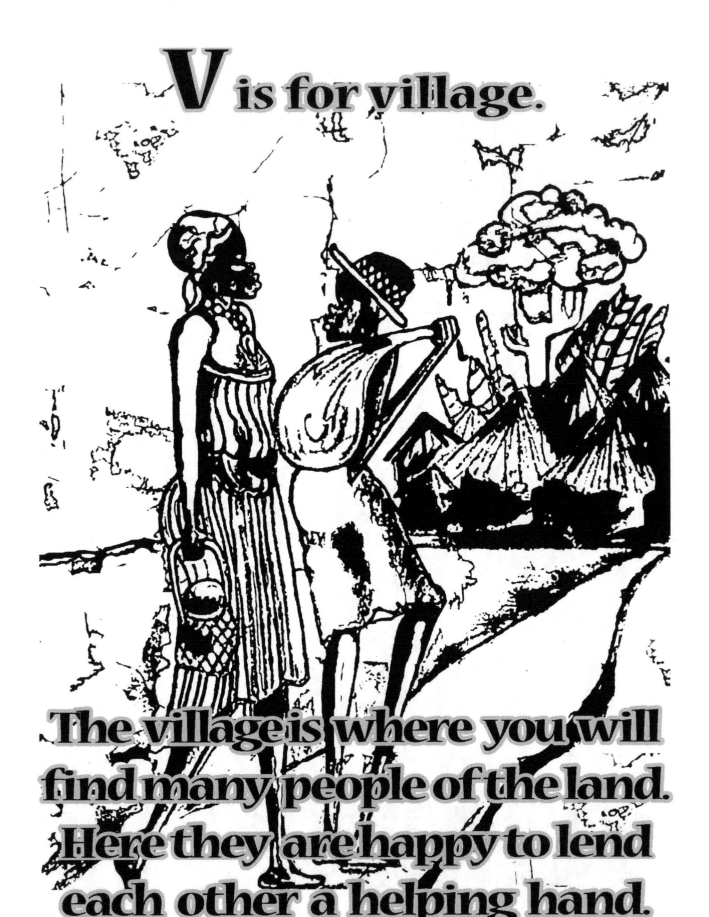

The village is where you will find many people of the land. Here they are happy to lend each other a helping hand.

# W is for warthog.
The warthog can easily be found rumbling around through tall grass or the dust of dry ground.

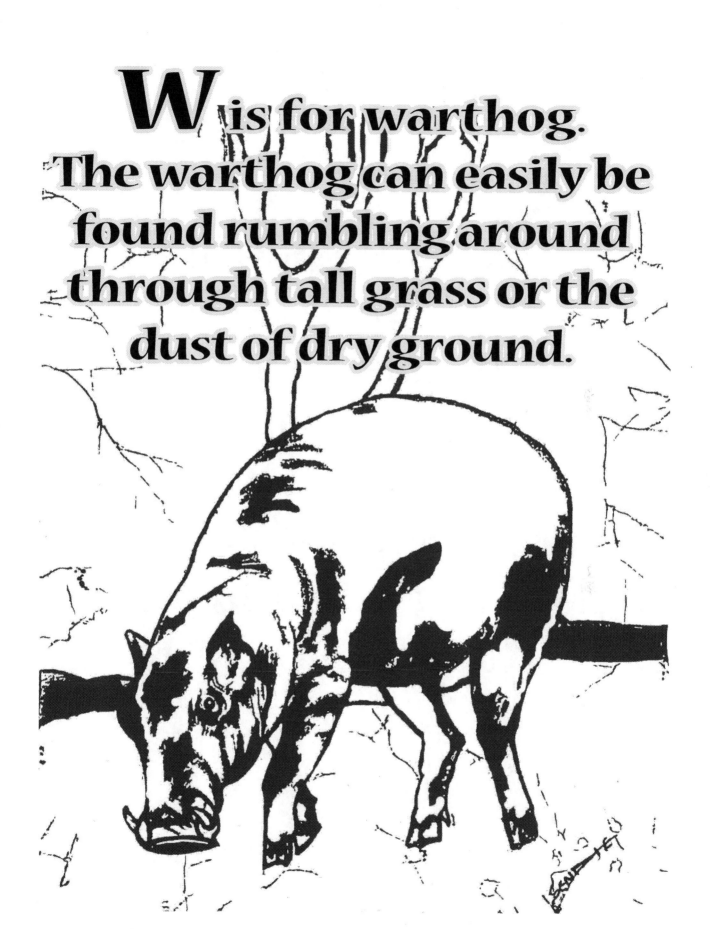

**X** is for Xolani.

Xolani, Saba, Nadijah, and Muata are just some of their names. Like you and me they love to laugh with friends, and play lots of games!

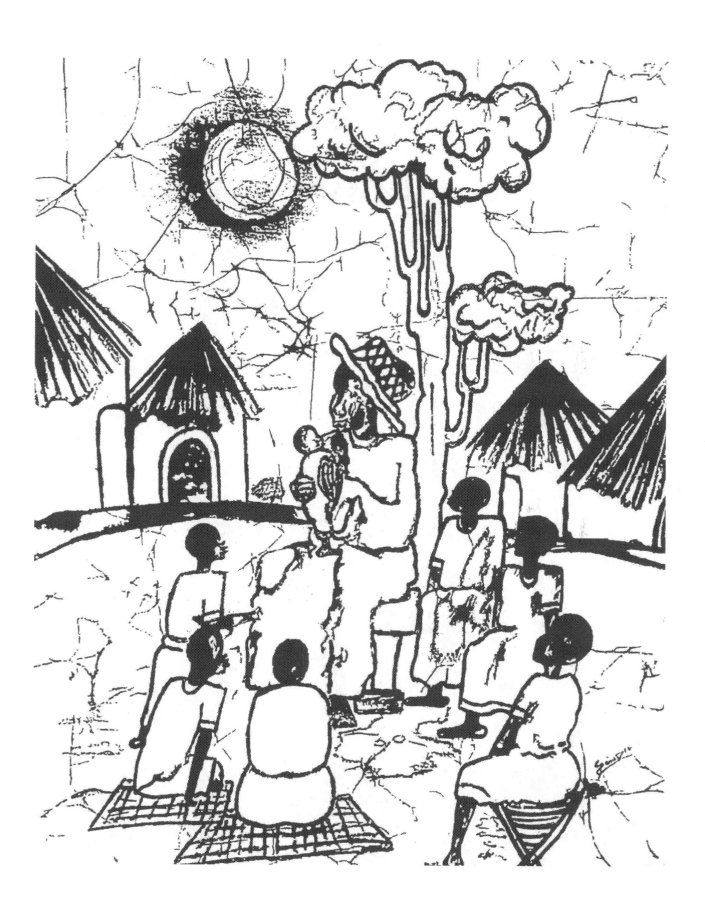

41

**Y** is for yellow mongoose.

The yellow mongoose makes a most curious sound. It walks with a wiggle and stays close to the ground.

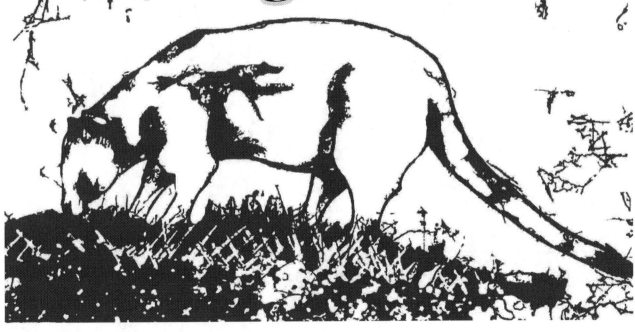

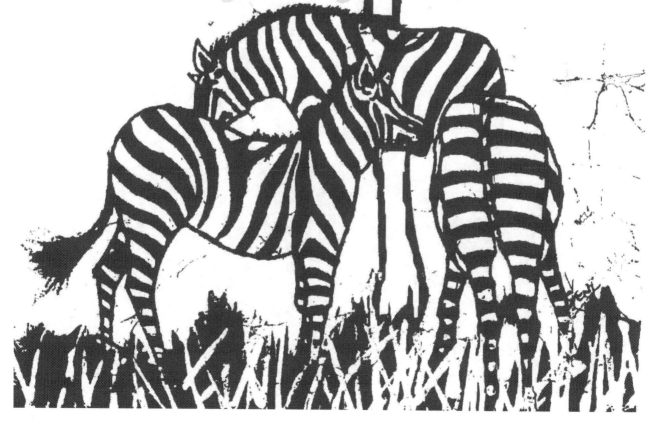

# Z is for zebra.

The zebra's stripes help keep
him safe, as you may know.
Even so, they are still careful
and always stay on their toes.

THE END

# About the Author:

The author currently resides in the city of Cleveland, Ohio with his wife and two sons. Michael obtained his bachelors in Elementary Education from Michigan State University ('96) and is currently working on his masters in Education at Cleveland State University. He has been working as a full-time youth minister and educator for over 15 years. On a trip to Uganda Africa in 2006, Michael got the inspiration for his first children's book, *A is for Africa,* and was fortunate enough to meet a local artist who helped to make that inspiration a reality. This coloring book was created with the intention of complimenting the original by encouraging and inspiring the artist who is within us all.

# About the Illustrator:

The illustrator currently resides in Uganda, Africa. His artwork often depicts the beautiful and diverse flora and fauna of the continent as well as the distinct characteristics of the native people and culture. Sswaga has been illustrating for almost 15 years, specializing in the unique "batik" style of painting used in this book. Each painting undergoes a special treatment of wax that helps accentuate and bring out desired colors and highlights. After the pieces are air dried, another layer of paint and wax are applied. This process continues until the desired picture is obtained. The works in full color can be found in the original alphabet book entitled, *A is for Africa,* by the same author and illustrator team.

Please send all correspondences for author & illustrator to goldeneggbooks@gmail.com.

Printed in the United States
by Baker & Taylor Publisher Services